Blessed Are the
CHILDREN

THE MIRACLE AND BEAUTY OF CHILDHOOD

Cover image *Consider the Lilies* © Simon Dewey courtesy of Altus Fine Art. For print information go to www.altusfineart.com.
Cover and book design by Jessica A. Warner © 2007 by Covenant Communications, Inc.
Published by Covenant Communications, Inc., American Fork, Utah

Printed in China
First Printing: September 2007

13 12 11 10 09 08 07 10 9 8 7 6 5 4 3 2 1

ISBN 978-1-59811-390-7

Blessed Are the

CHILDREN

THE MIRACLE AND BEAUTY OF CHILDHOOD

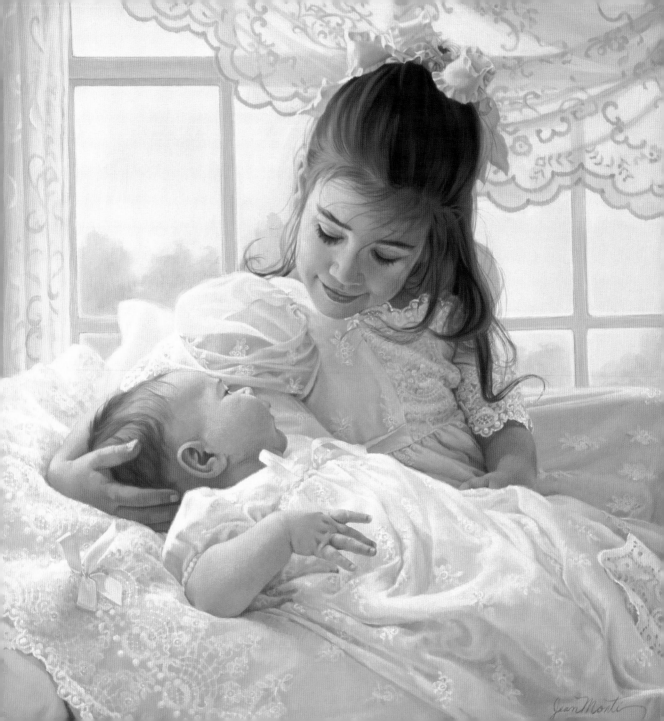

\mathcal{N}ever forget that these little ones are the sons and daughters of God and that yours is a custodial relationship to them, that He was a parent before you were parents and that He has not relinquished His parental rights or interest in these little ones. Now, love them, take care of them. . . . welcome them into your homes and nurture and love them with all of your hearts.

—Gordon B. Hinckley

If our American way of life
fails the child, it fails us all.

—Pearl S. Buck

As we struggle to understand the contemporary world, to find a moral compass, to overcome selfishness, to develop moral character and compassion, and to uncover our calling, we may find a wellspring very close to home, in the authentic spiritual life of children. —*Tobin Hart*

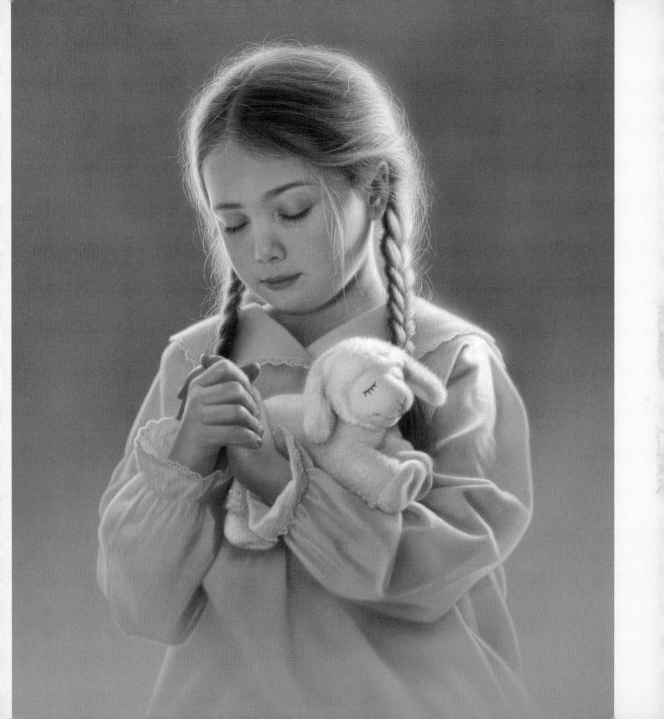

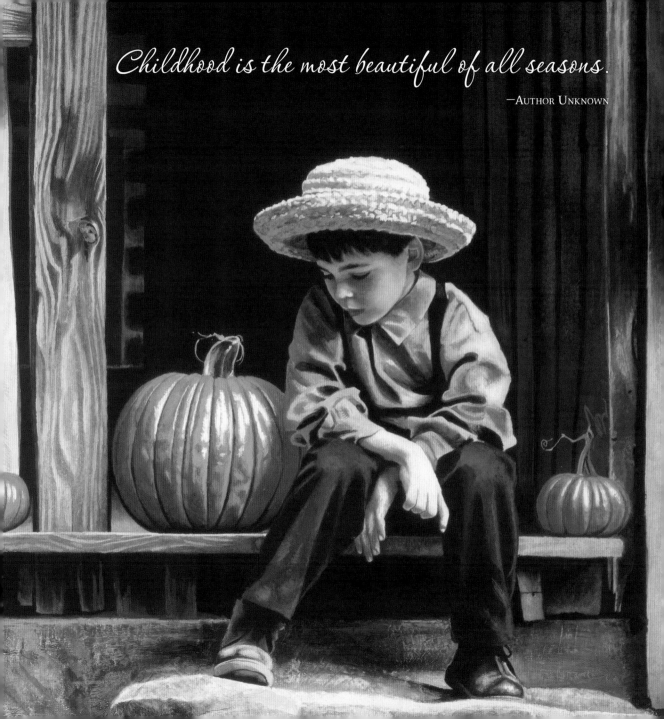

Childhood is the most beautiful of all seasons.

—AUTHOR UNKNOWN

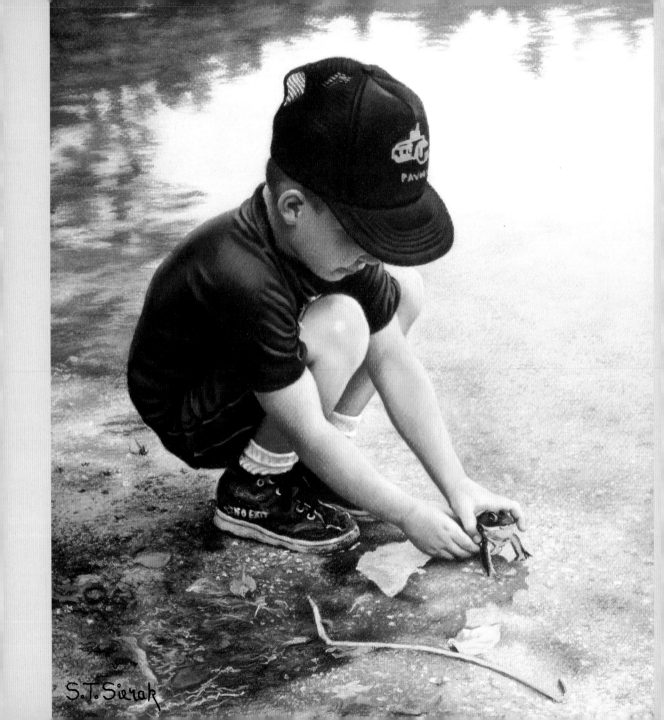

There are no seven

wonders of the world

in the eyes of a child.

There are seven million.

-Walt Streightiff

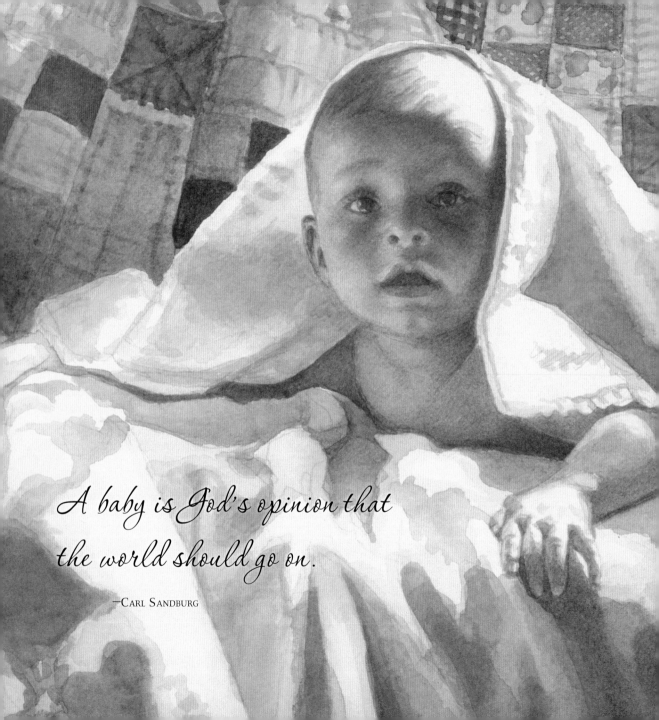

A baby is God's opinion that
the world should go on.

—CARL SANDBURG

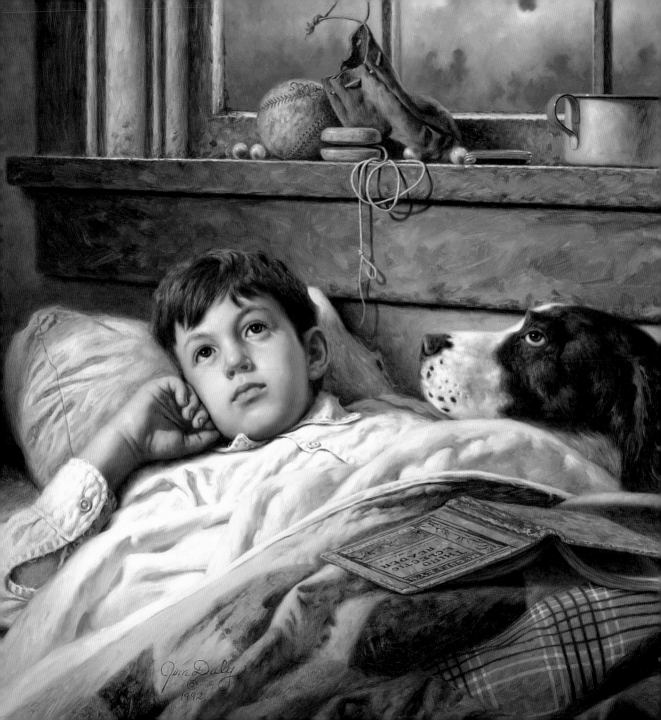

A young child is, indeed, a true scientist, just one big question mark. What? Why? How? I never cease to marvel at the recurring miracle of growth, to be fascinated by the mystery and wonder of this brave enthusiasm.

—*Victoria Wagner*

*C*hildren are the keys of Paradise,

They alone are good and wise,

Because their thoughts,

their very lives, are prayer.

—*Richard Henry Stoddard*

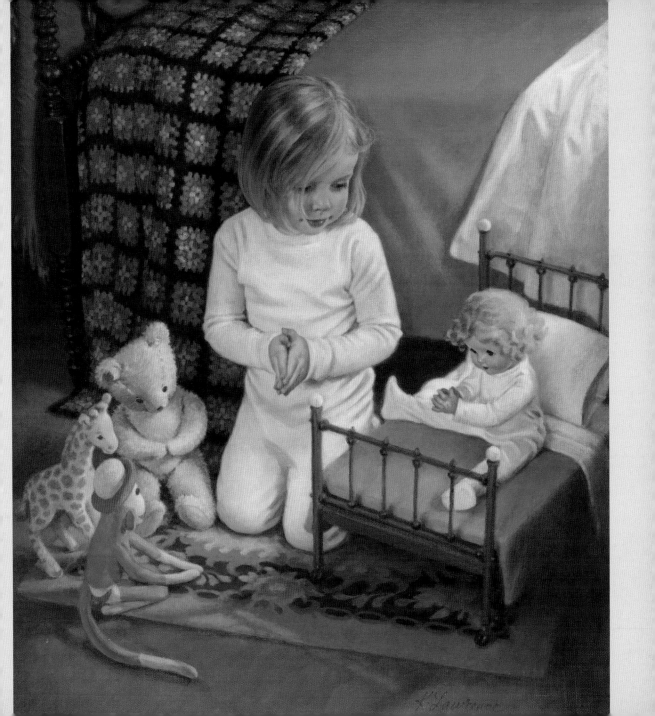

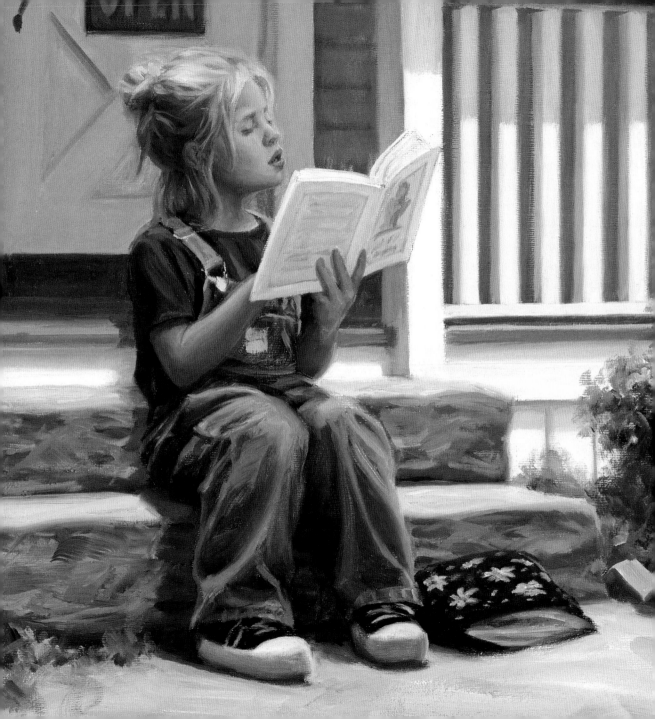

*Y*our children are not your children. They are the sons and daughters of Life's longing for itself. You may house their bodies but not their souls, for their souls dwell in the house of tomorrow, which you cannot visit, not even in your dreams.

—Kahlil Gibran

*I*f help and salvation are to come,

they can only come from the children,

for the children are the makers of men.

—*Maria Montessori*

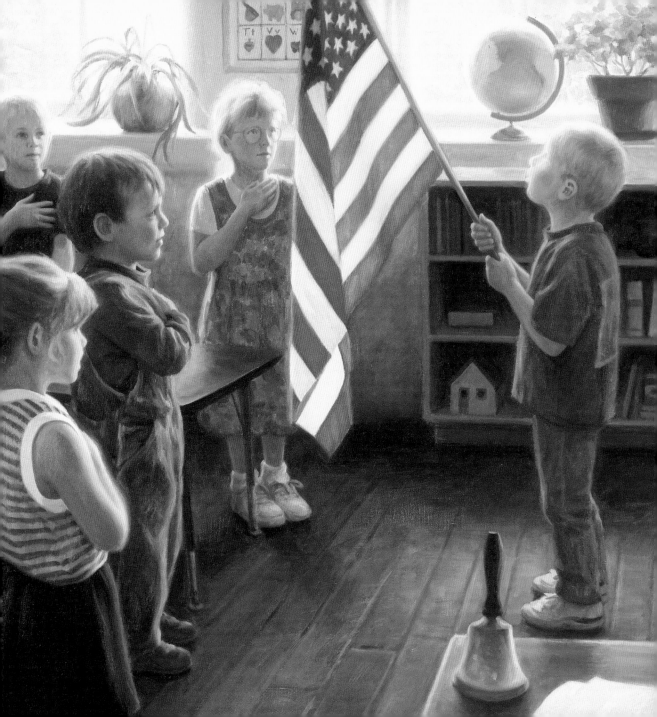

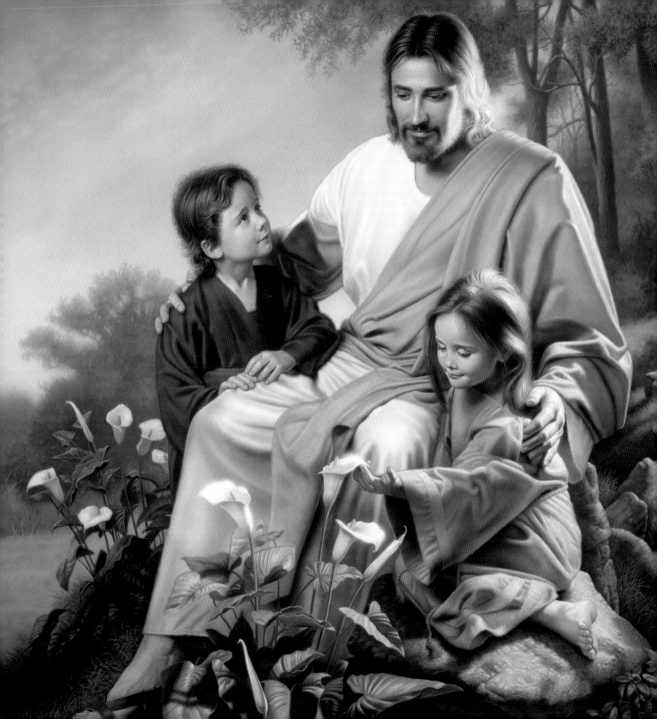

Bitter are the tears of a child: Sweeten them.

Deep are the thoughts of a child: Quiet them.

Sharp is the grief of a child: Take it from him.

Soft is the heart of a child: Do not harden it.

—Pamela Glenconner

Kids:
They dance
before they learn
there is anything
that isn't music.

—William Stafford

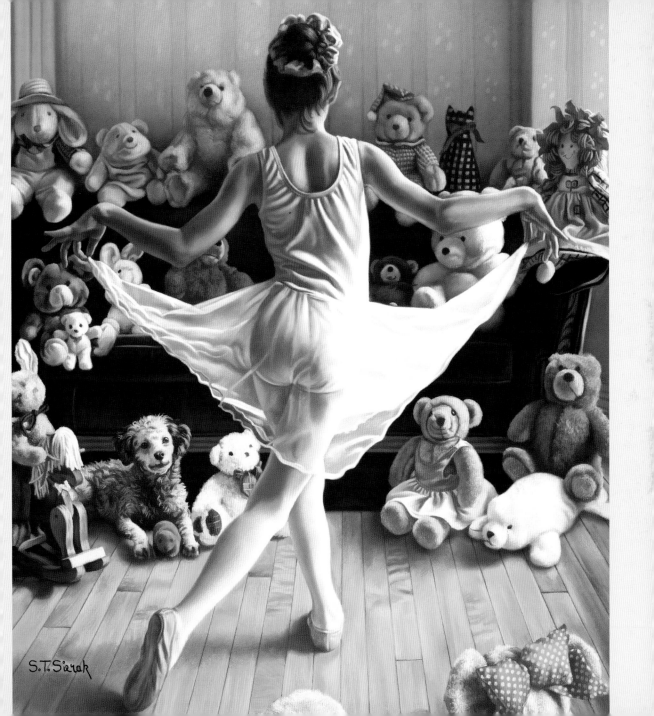

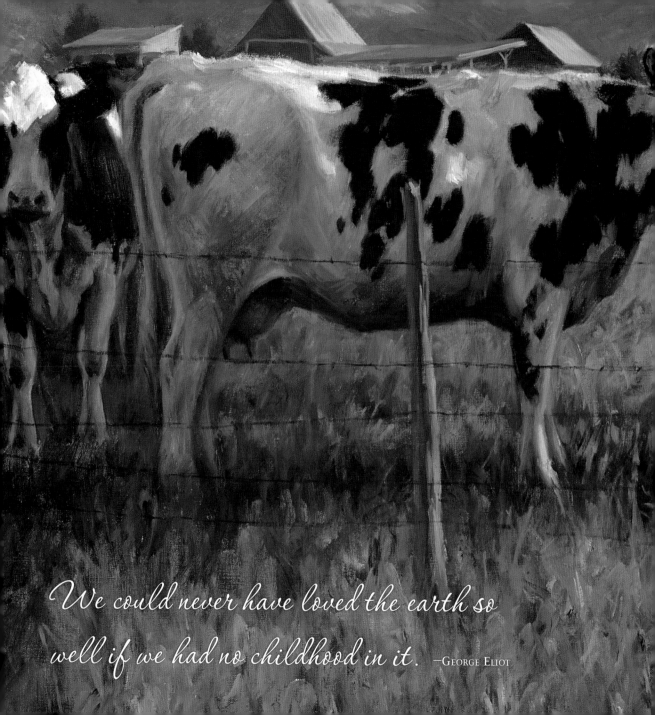

We could never have loved the earth so well if we had no childhood in it. —George Eliot

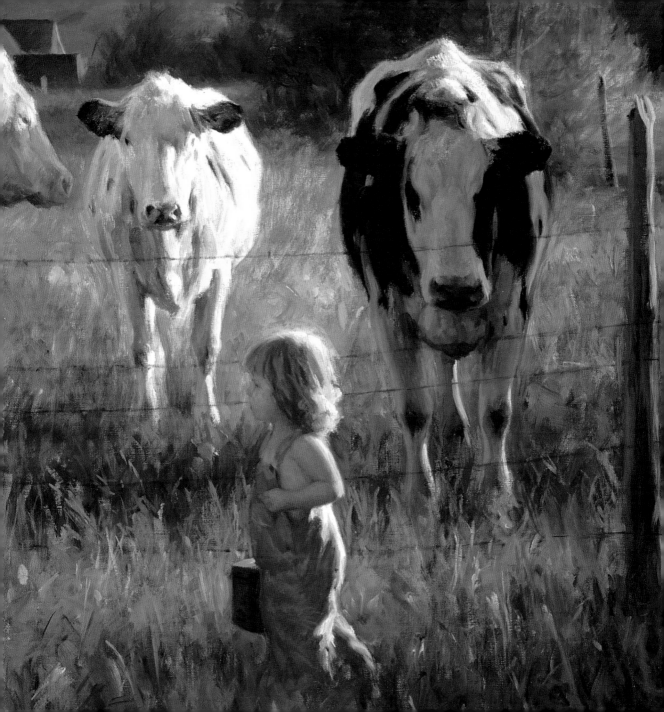

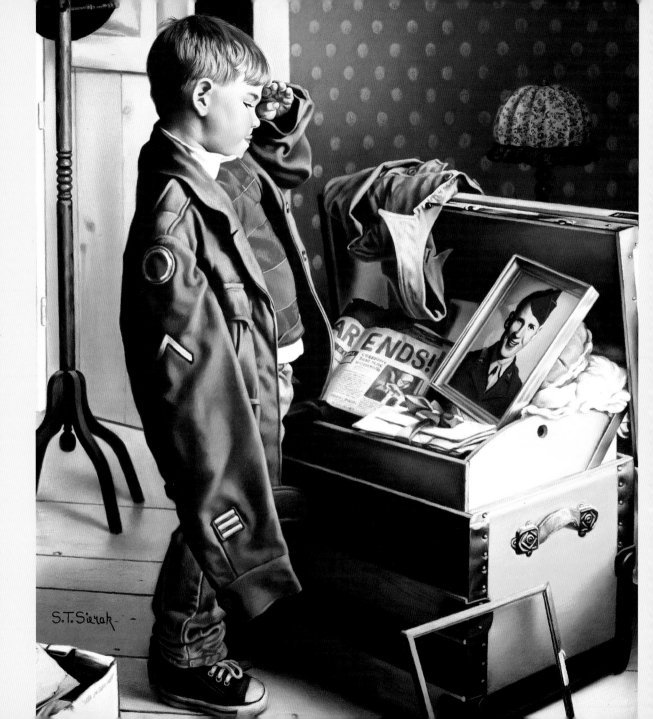

Men, in general, are but great children.

−NAPOLEON BONAPARTE

Play is often talked about as if it
were a relief from serious learning.
But for children play is serious learning.
Play is really the work of childhood.

—Fred Rogers

\mathcal{O}ur children are

not going to be just

"our children"—they

are going to be other

people's husbands and

wives and the parents

of our grandchildren.

—Mary Steichen Calderone

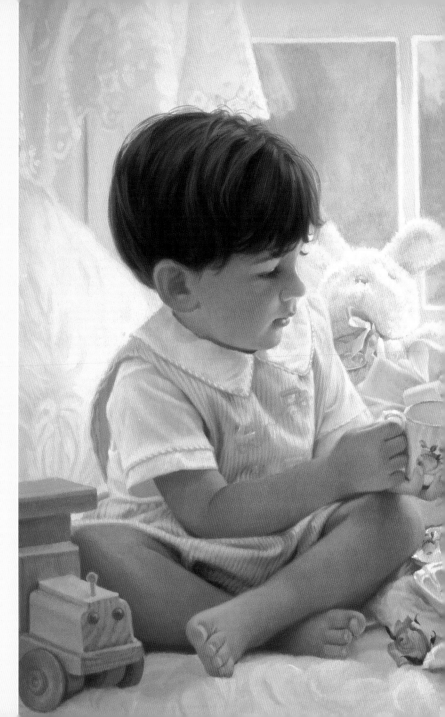

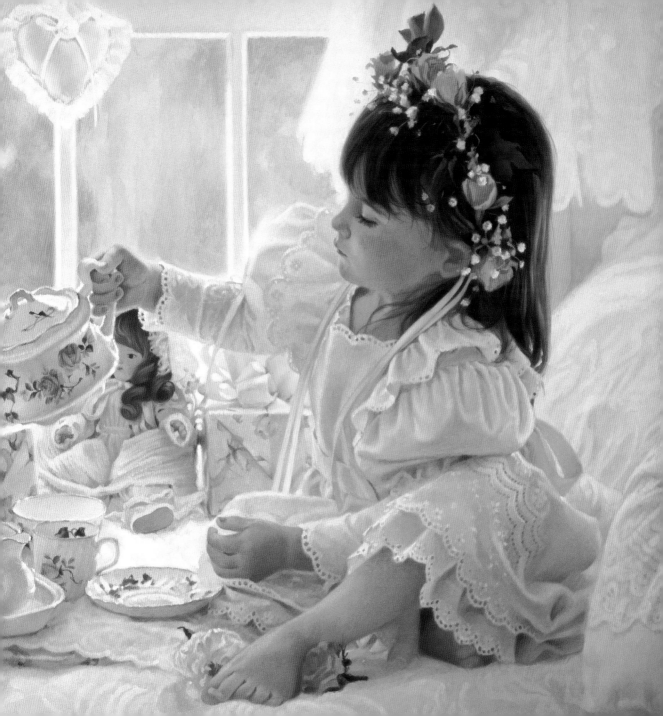

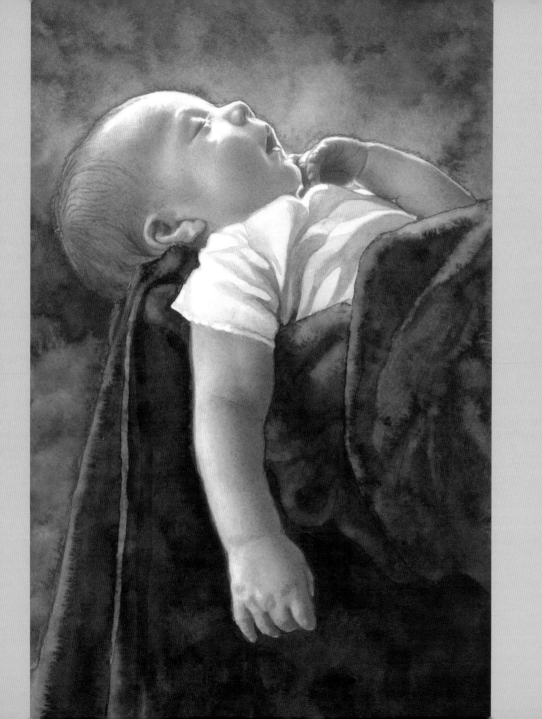

When God wants a great work done in the world or a great wrong righted, he goes about it in a very unusual way. He doesn't stir up his earthquakes or send forth his thunderbolts. Instead, he has a helpless baby born, perhaps in a simple home of some obscure mother. And then God puts the idea into the mother's heart, and she puts it into the baby's mind. And then God waits. The greatest forces in the world are not the earthquakes and the thunderbolts. The greatest forces in the world are babies.

—E. T. Sullivan

The most effective kind of
education is that a child should play
amongst lovely things.

—*Plato*

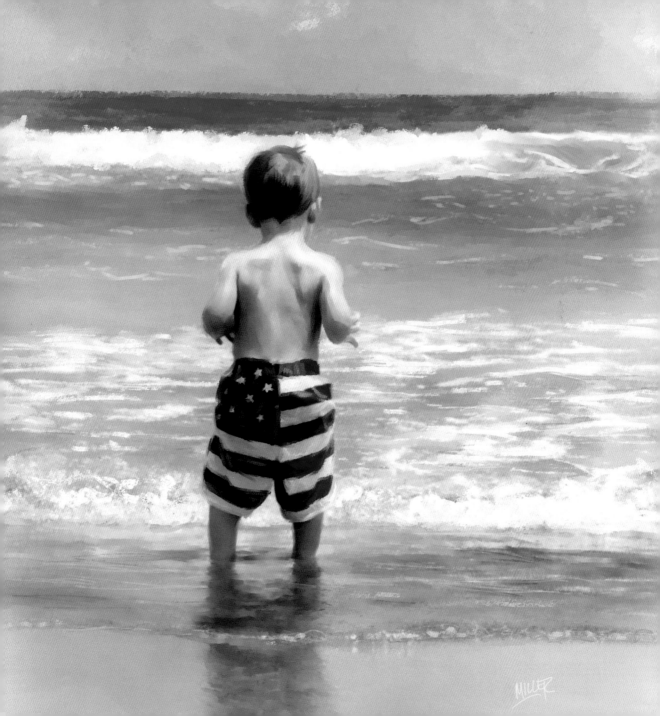

Children make you want to start life over. —Muhammad Ali

Childhood is measured out by sounds and smells and sights, before the dark hour of reason grows. —*John Betjeman*

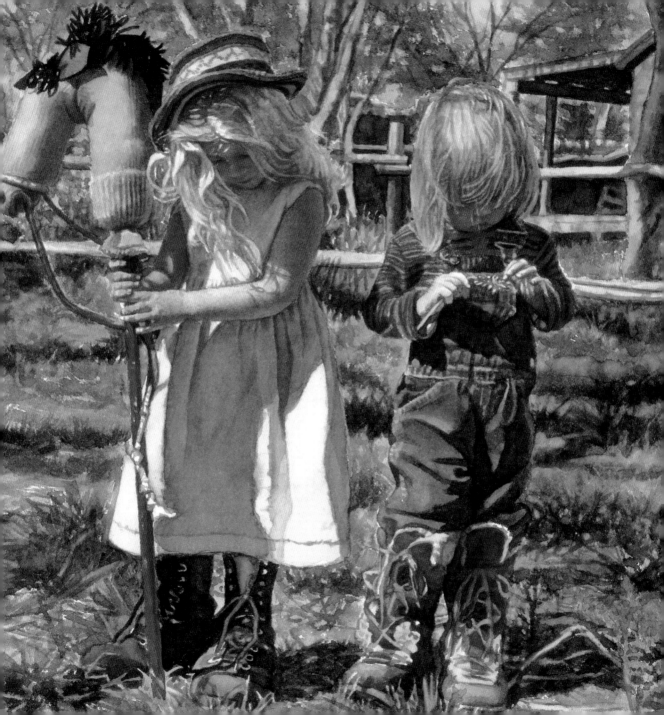

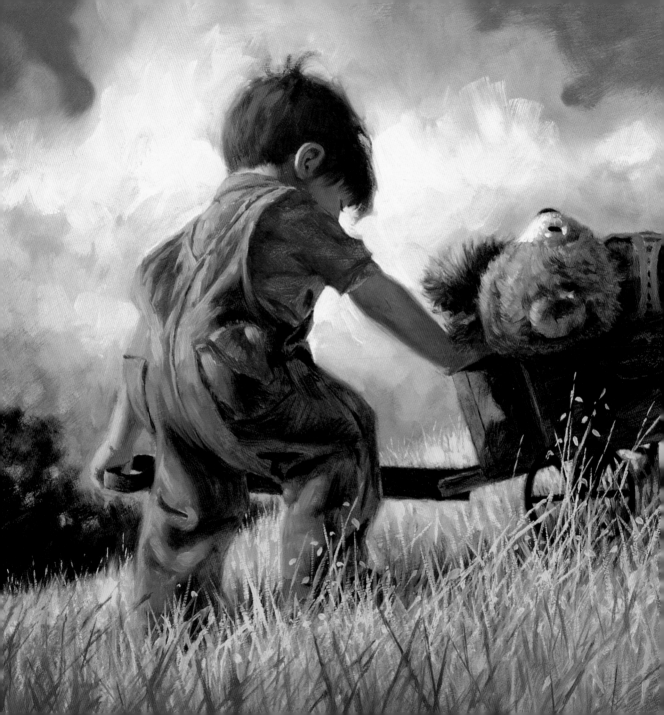

\mathcal{Y}ou are worried about seeing him spend his early years in doing nothing. What! Is it nothing to be happy? Nothing to skip, play, and run around all day long? Never in his life will he be so busy again.

—*Jean-Jacques Rousseau*

I think, at a child's birth,

if a mother could ask a fairy godmother

to endow it with the most useful gift,

that gift would be curiosity.

—*Eleanor Roosevelt*

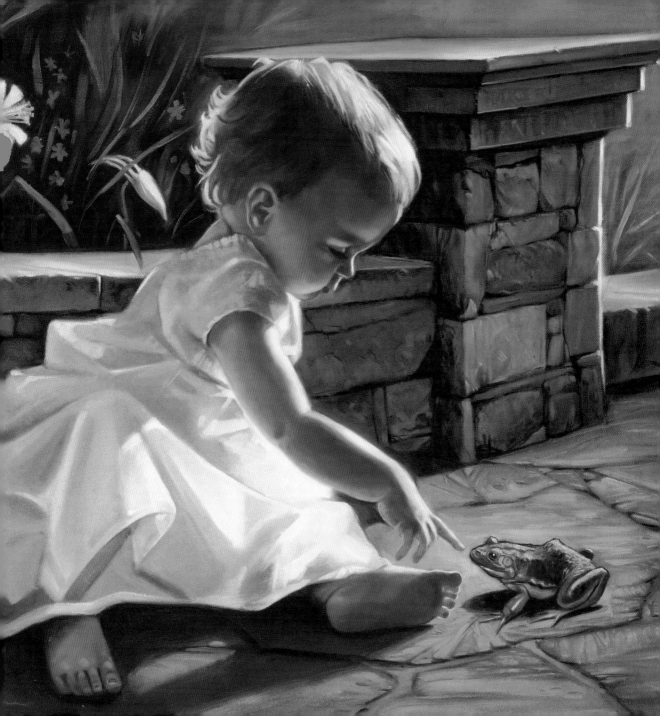

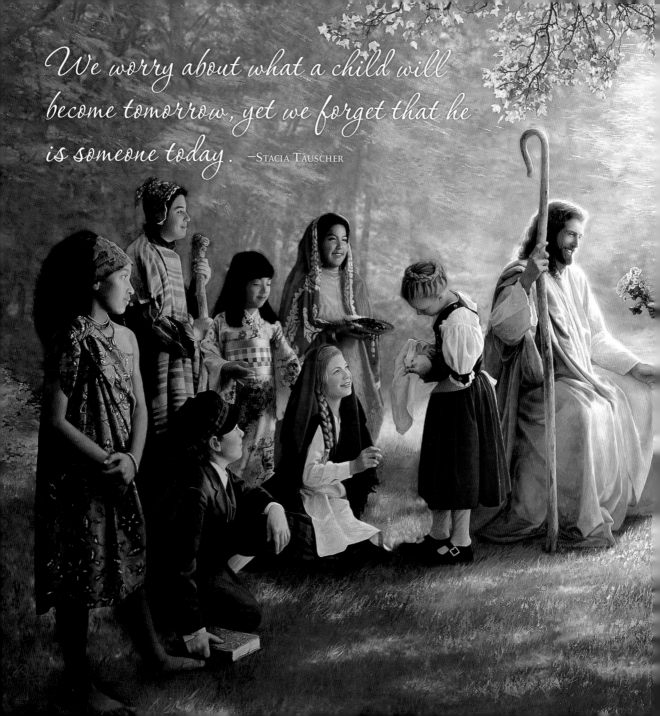

We worry about what a child will become tomorrow, yet we forget that he is someone today. —STACIA TAUSCHER

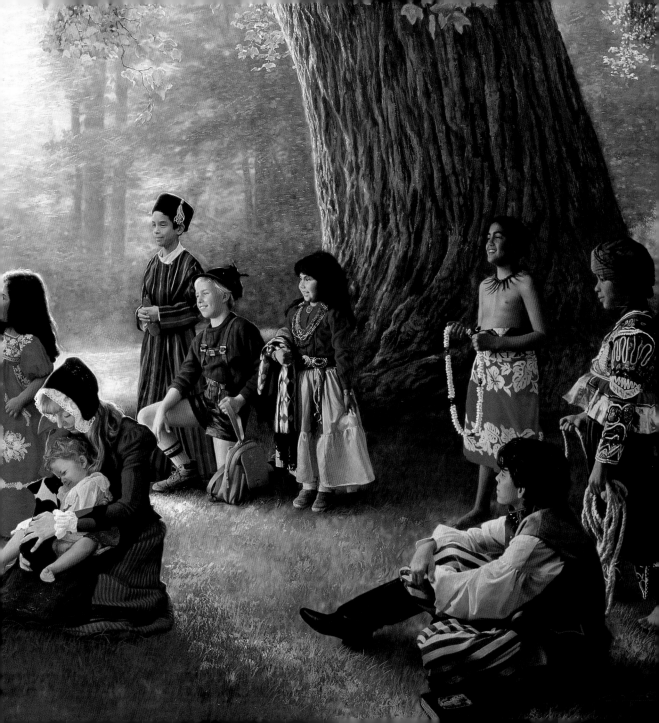

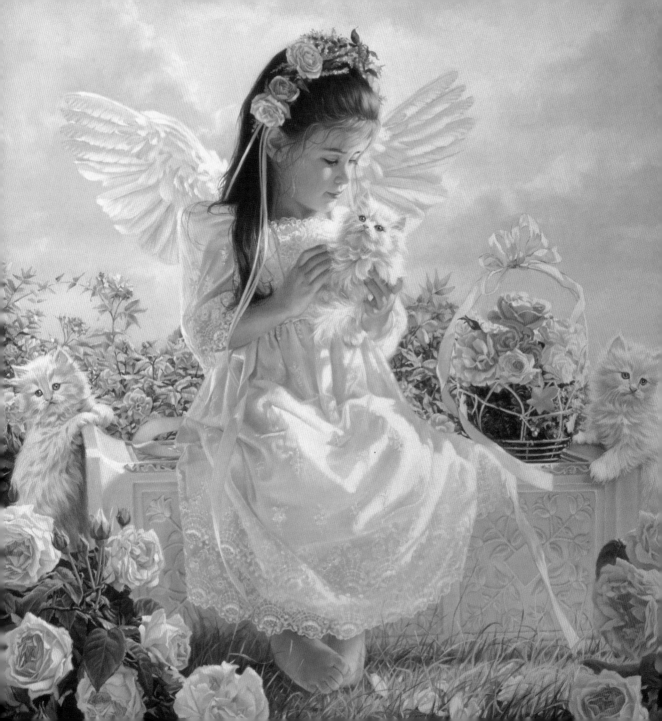

A child is an angel dependent on man.

-JOSEPH MARIE DE MAISTRE

When the first baby laughed for the first time,

the laugh broke into a thousand pieces

and they all went skipping about,

and that was the beginning of the fairies.

—Sir James M. Barrie

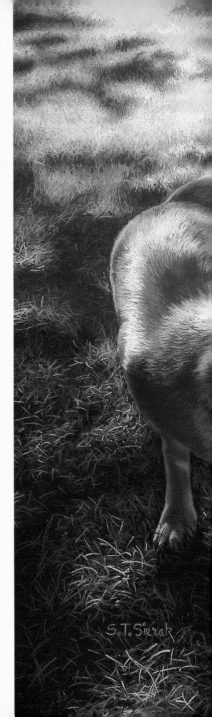

My lovely living Boy,
My hope, my hap, my Love,
my life, my joy.

—Guillaume de Saulluste Du Bartas

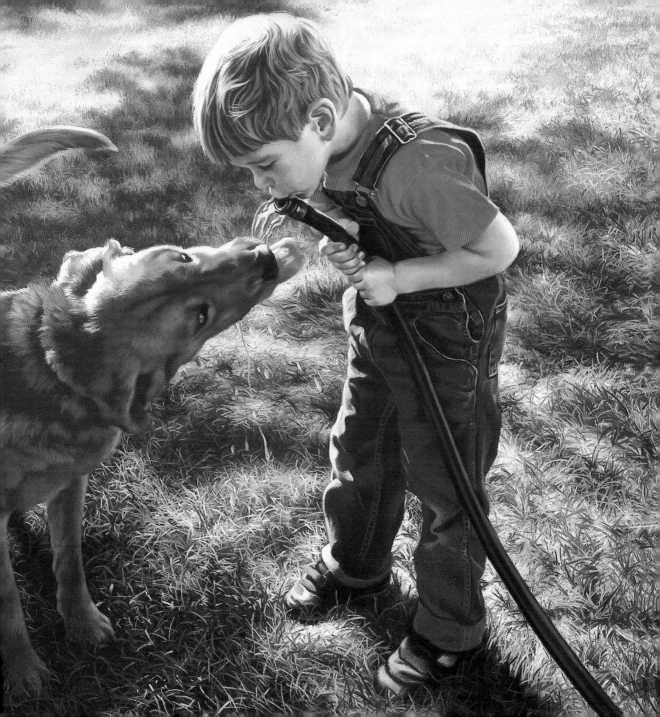

There is always one moment in childhood when the door opens and lets the future in.

—DEEPAK K. CHOPRA

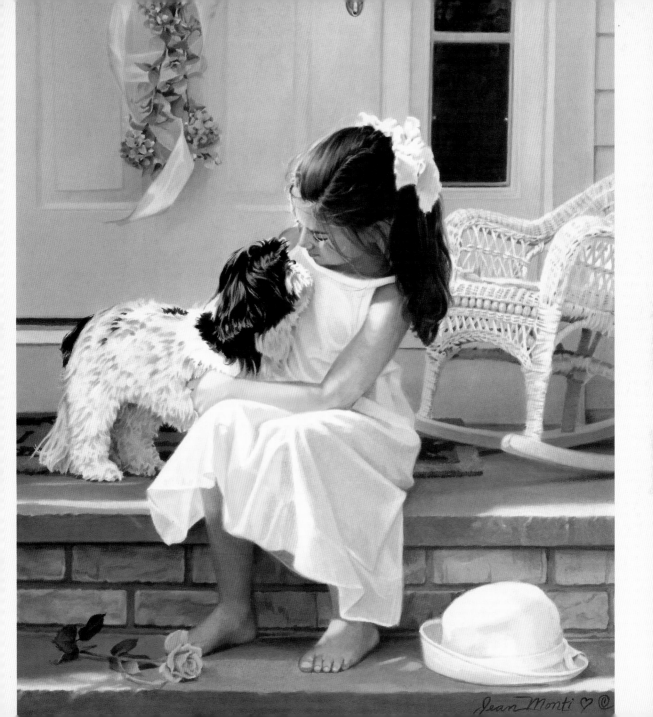

Jean Monti ♥ ©

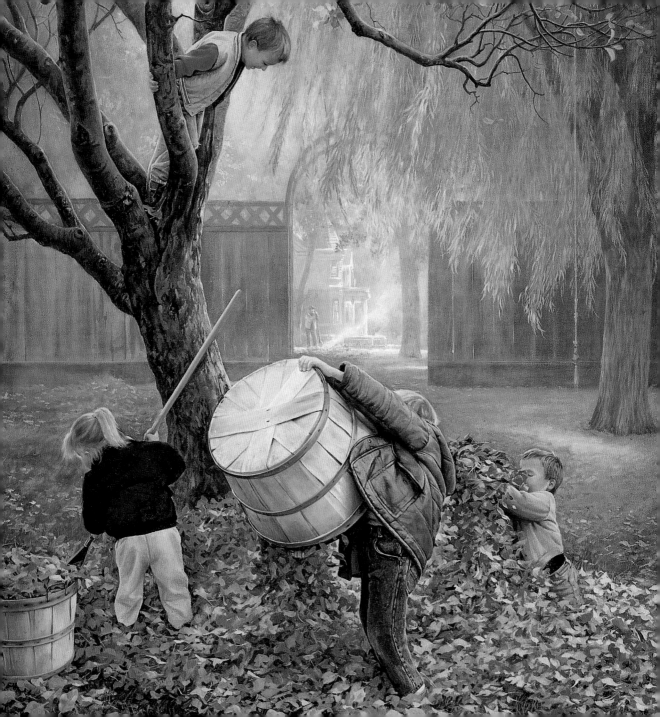

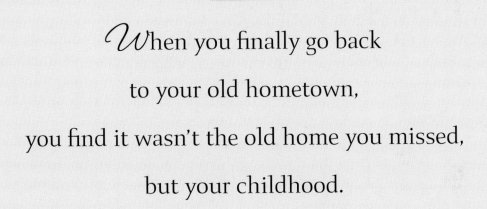

*W*hen you finally go back

to your old hometown,

you find it wasn't the old home you missed,

but your childhood.

—*Sam Ewing*

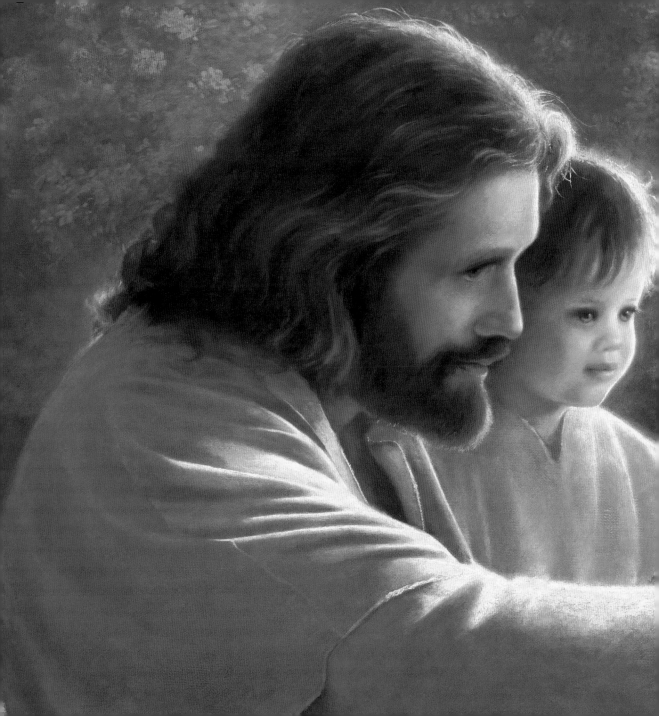

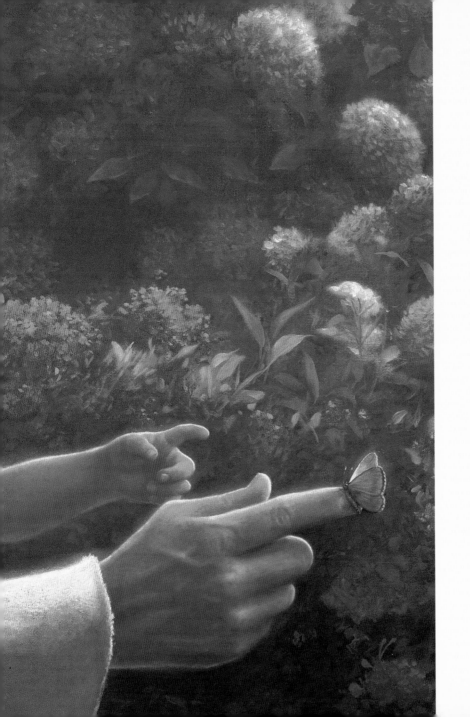

\mathcal{L}ove your children.
Cherish them. They are so
precious. They are so very,
very important. They are
the future. You need more
than your own wisdom in
rearing them. You need the
help of the Lord.... Pray
for that help and follow
the inspiration which you
receive. —*Gordon B. Hinckley*

*Each child is an
adventure into a better
life—an opportunity to
change the old pattern
and make it new.*

—HUBERT H. HUMPHREY

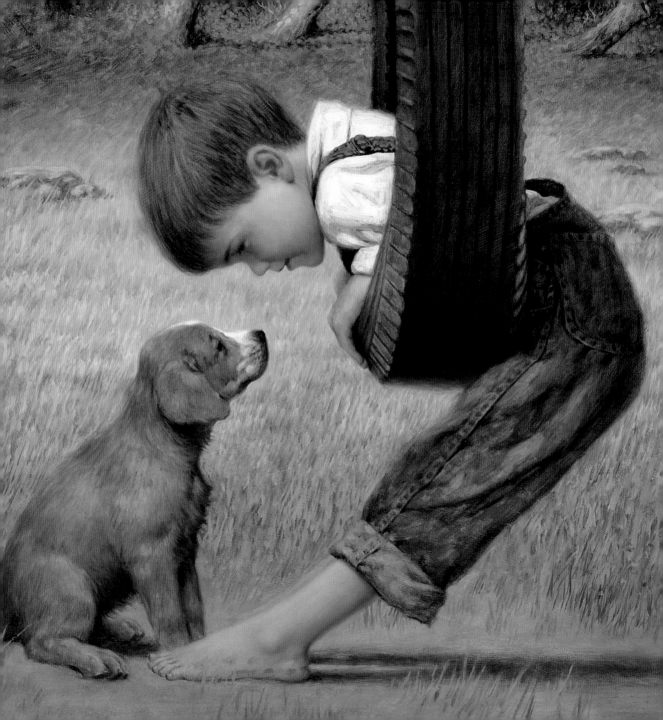

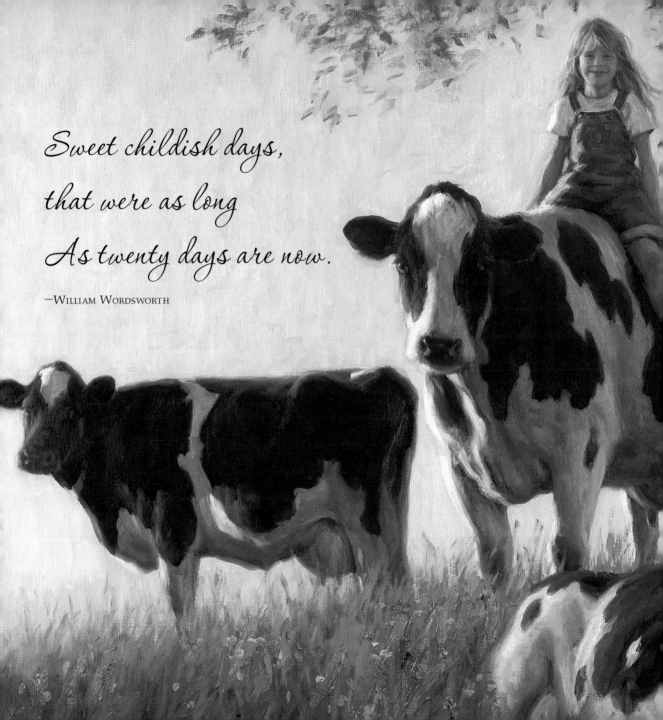

Sweet childish days,
that were as long
As twenty days are now.

—WILLIAM WORDSWORTH

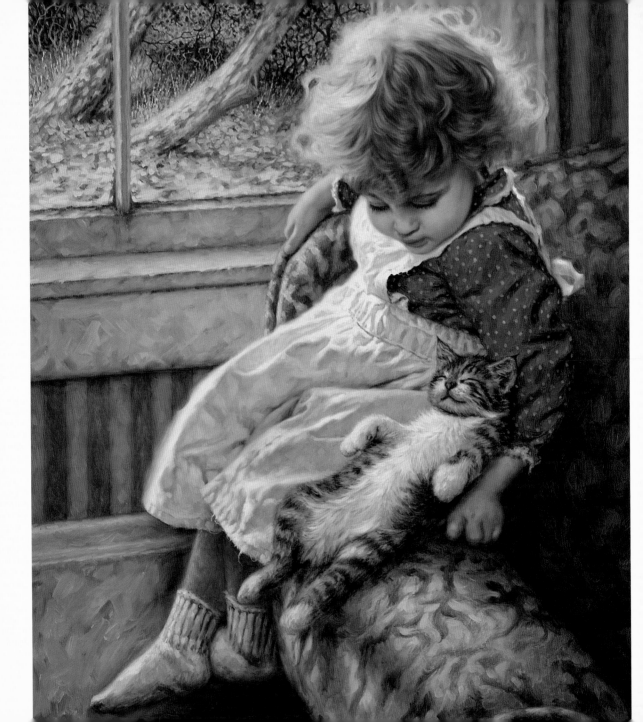

Nothing you do for children is ever wasted.
-GARRISON KEILLOR

\mathcal{W}e should treat children as God does us,
who makes us happiest when he leaves us
under the influence of innocent delusions.

—Johann Wolfgang von Goethe

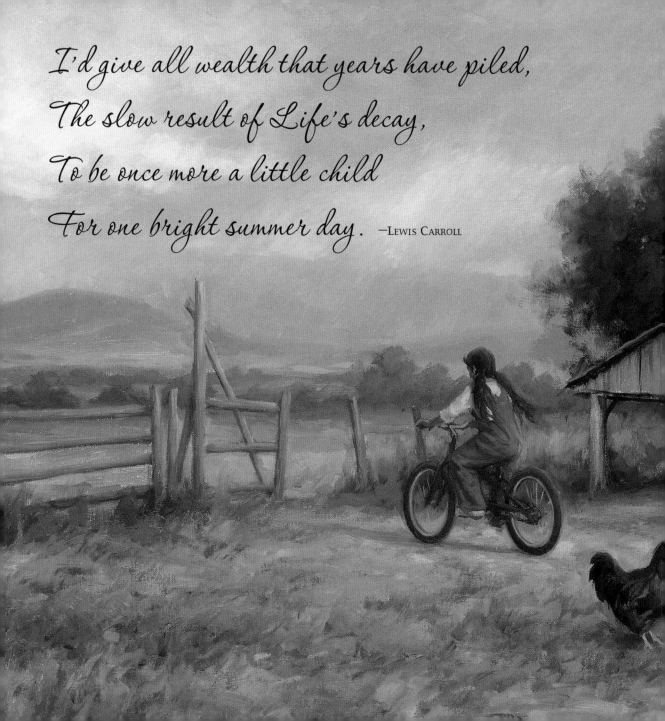

I'd give all wealth that years have piled,

The slow result of Life's decay,

To be once more a little child

For one bright summer day. —Lewis Carroll

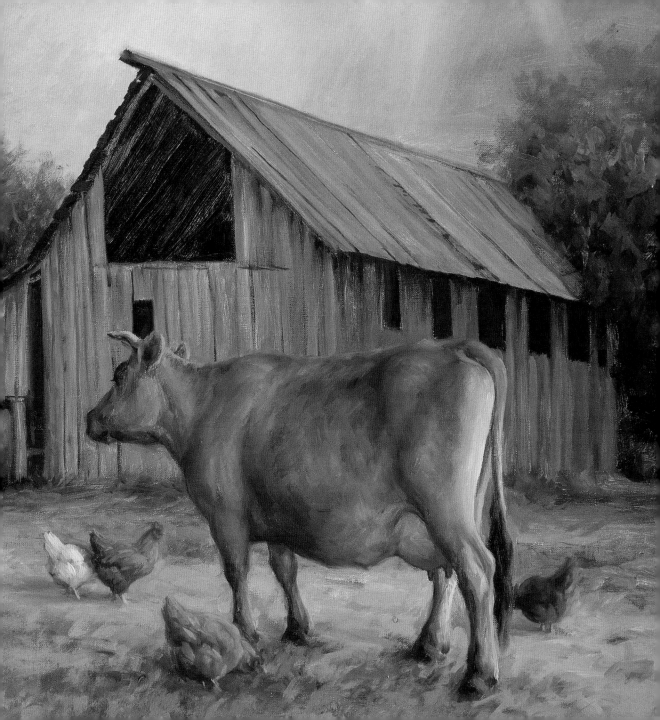

*Every child is born
a potential genius.*

–Buckminster Fuller

And he who gives a child a treat

Makes Joy-bells ring in Heaven's street,

And he who gives a child a home

Builds palaces in Kingdom come,

And she who gives a baby birth,

Brings Saviour Christ again to earth.

—John Masefield

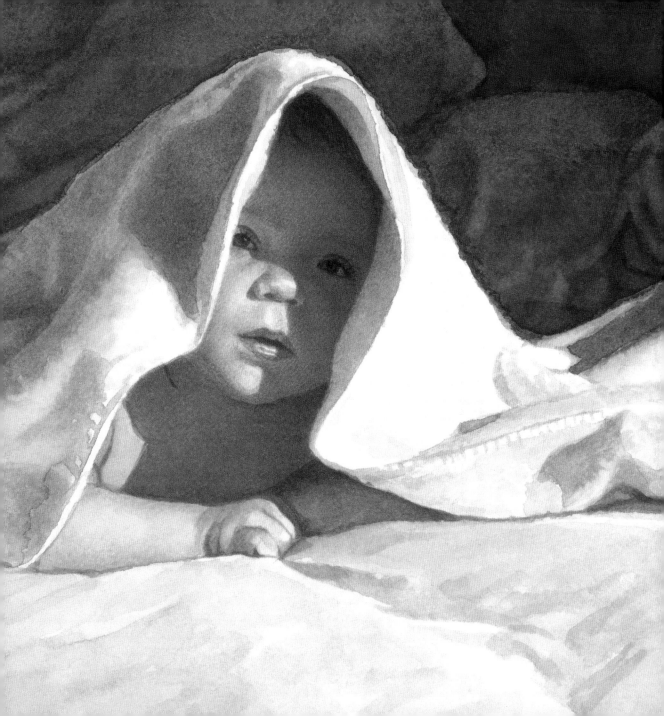

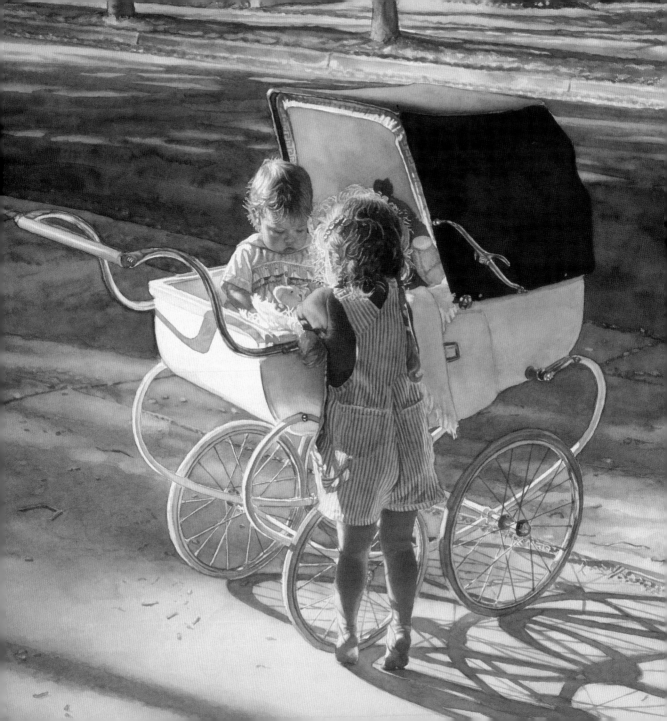

I love these little people;
and it is not a slight thing,
when they, who are so fresh
from God, love us.

−CHARLES DICKENS

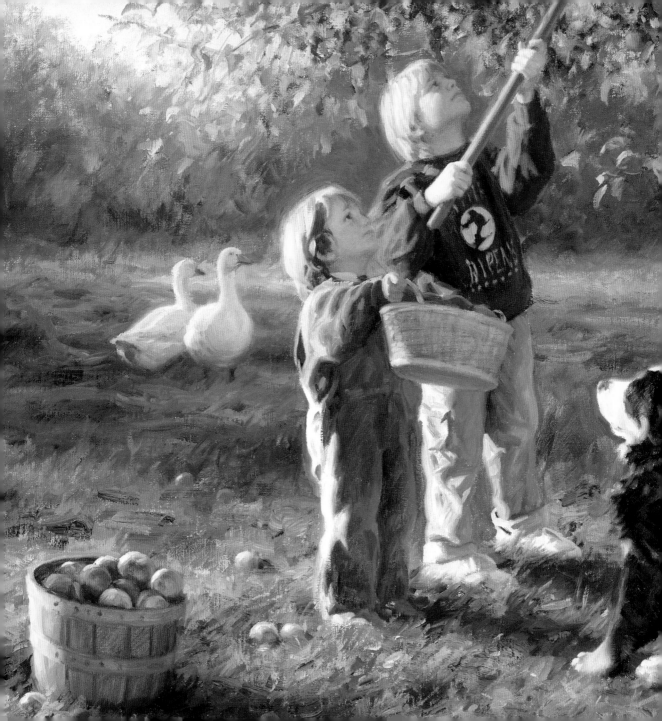

We all must work
to make the world
worthy of its children.

–Pablo Casals

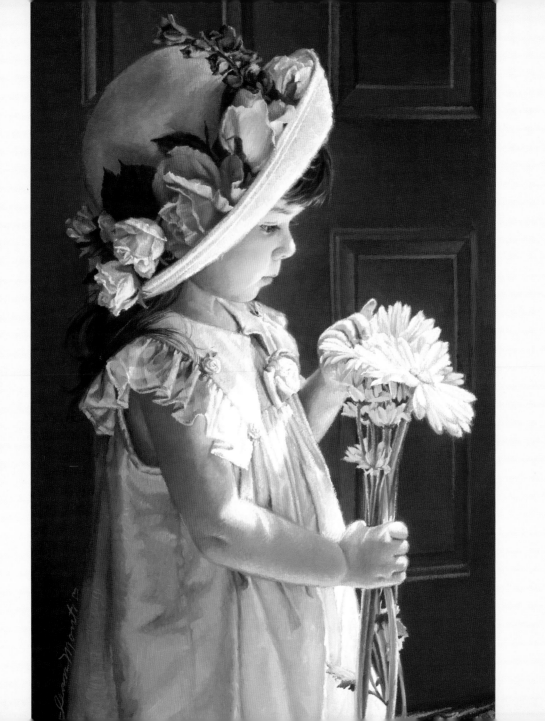

Every child comes with the message
that God is not yet discouraged of man.

—Rabindranath Tagore

The child must know that he is a miracle,

that since the beginning of the world there hasn't been,

and until the end of the world there will not be,

another child like him.

—*Pablo Casals*

The soul is healed by being with children.

—DOSTOEVSKY

Few things can transform us as

quickly as the presence of a child.

—*Tobin Hart*

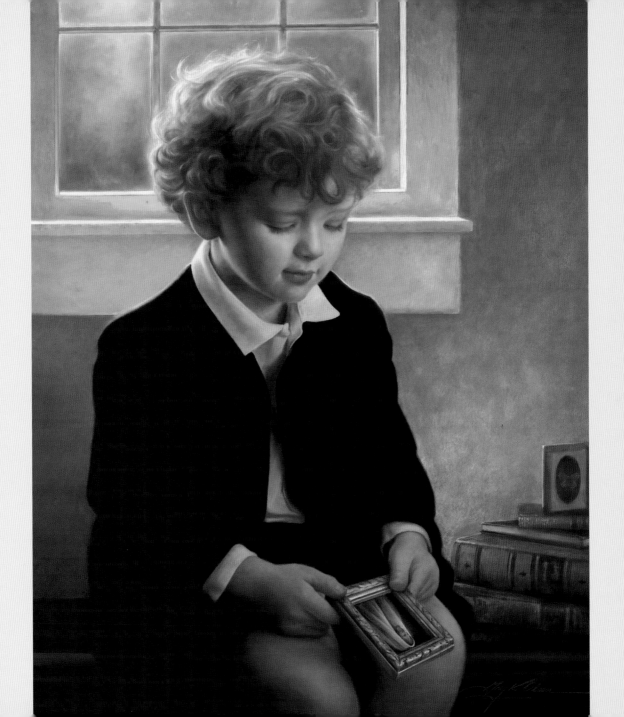

Children are a poor man's wealth.

—Danish Proverb

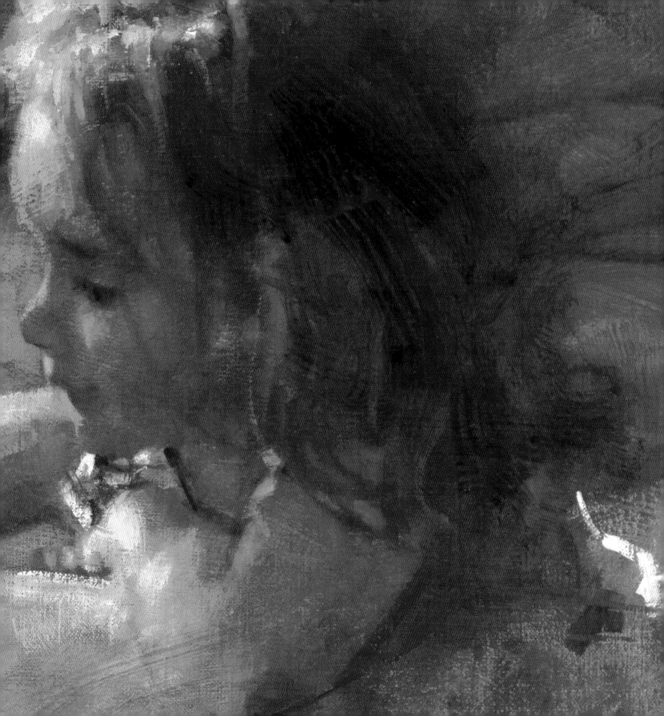

Children are the living messages we send
to a time we will not see.

—John W. Whitehead

If there is anything that will endure

The eye of God, because it still is pure,

It is the spirit of a little child,

Fresh from his hand, and therefore undefiled.

—Richard Henry Stoddard

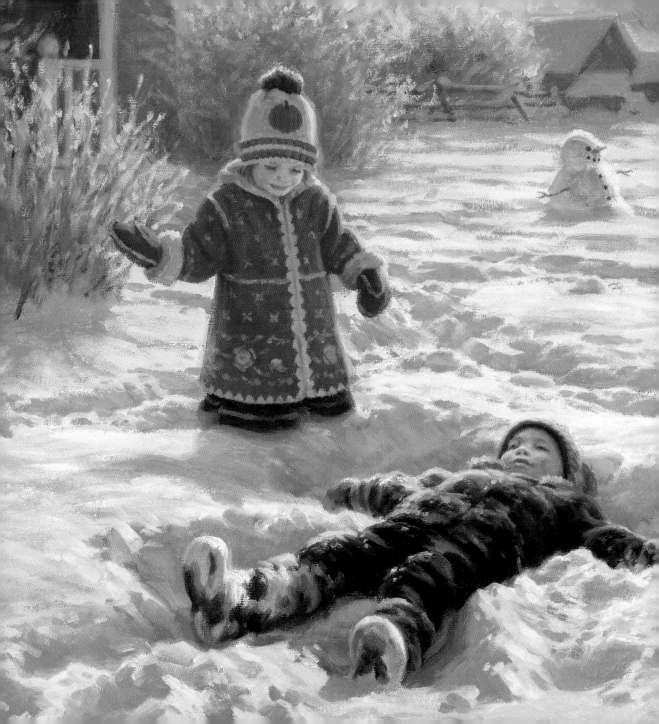

\mathcal{A}h! what would the world be to us

If the children were no more?

We should dread the dark desert behind us

Worse than the dark before.

—*Henry Wadsworth Longfellow*

\mathcal{G}rown men can learn from

very little children,

for the hearts of little

children are pure. Therefore,

the Great Spirit may

show to them many things

which older people miss.

—*Black Elk*

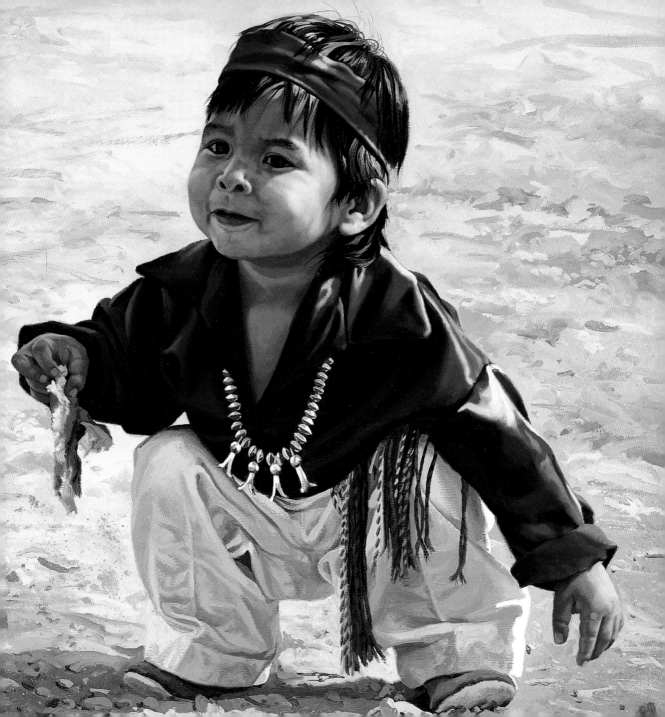

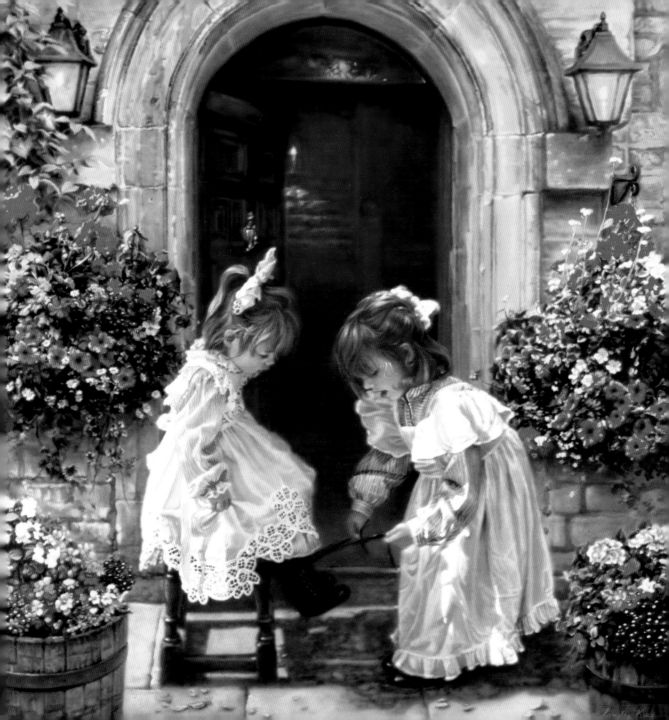

\mathcal{W}hile we are trying to

teach our children all about life,

our children teach us

what life is all about.

—*Angela Schwindt*

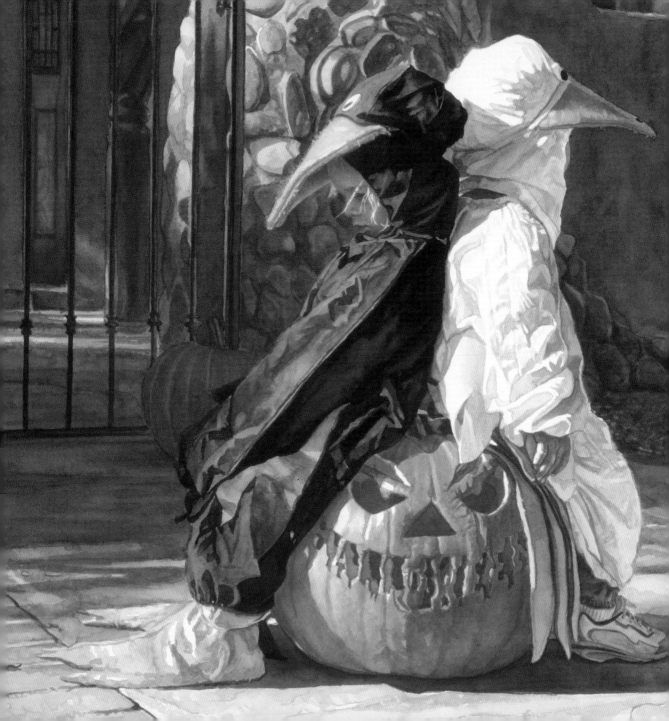

Children find everything in nothing; men find nothing in everything. —Giacomo Leopardi

The pursuit of truth and beauty is a sphere of activity in which we are permitted to remain children all our lives. —*Albert Einstein*

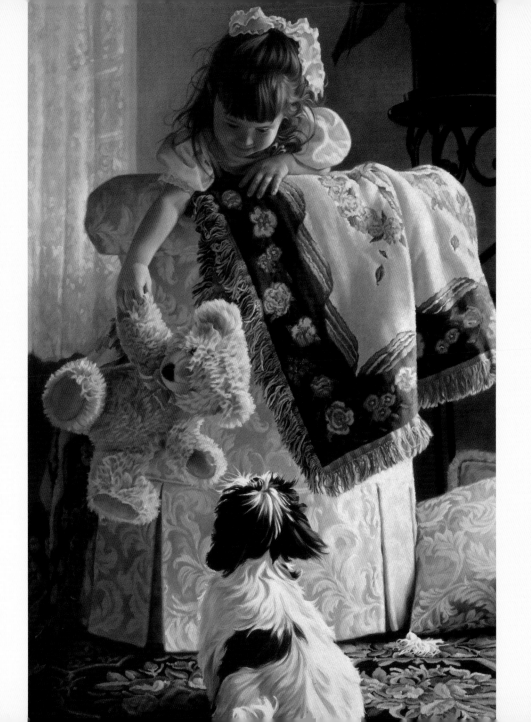

Children are the past, the present,

and the future all blended into one.

They are consummately precious.

Every time a child is born,

the world is renewed in innocence.

—*Boyd K. Packer*

Children are our most valuable natural resource. —HERBERT HOOVER

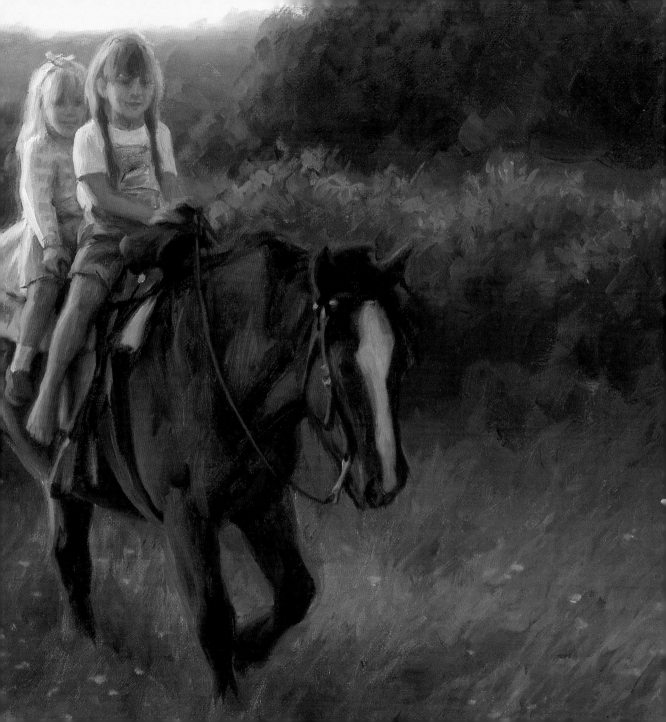

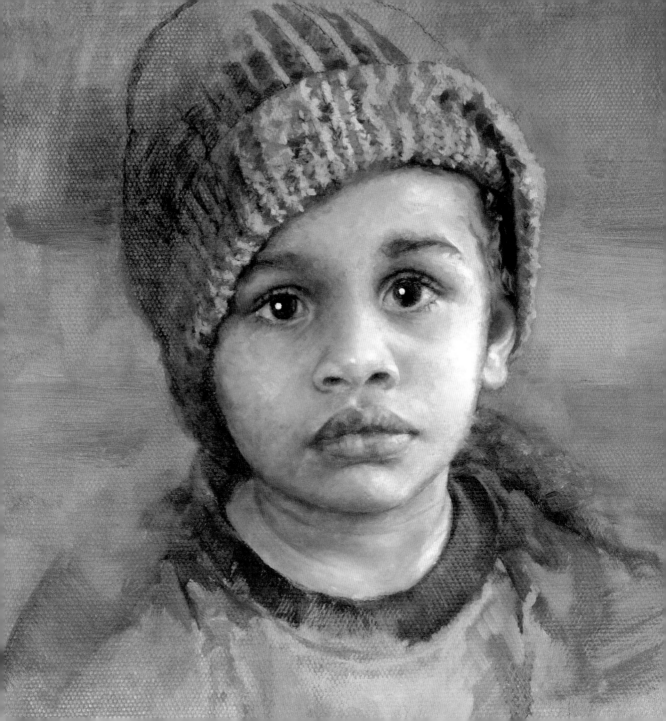

\mathcal{A} child's eyes, those clear wells of undefiled thought—
what on earth can be more beautiful? Full of hope, love and
curiosity, they meet your own. In prayer, how earnest; in joy,
how sparkling; in sympathy, how tender! The man who never
tried the companionship of a little child has carelessly passed
by one of the great pleasures of life, as one passes a rare
flower without plucking it or knowing its value.

—*Angela Schwindt*

Life has loveliness to sell,

All beautiful and splendid things,

Blue waves whitened on a cliff,

Soaring fire that sways and sings

And children's faces looking up

Holding wonder like a cup.

—*Sara Teasdale*

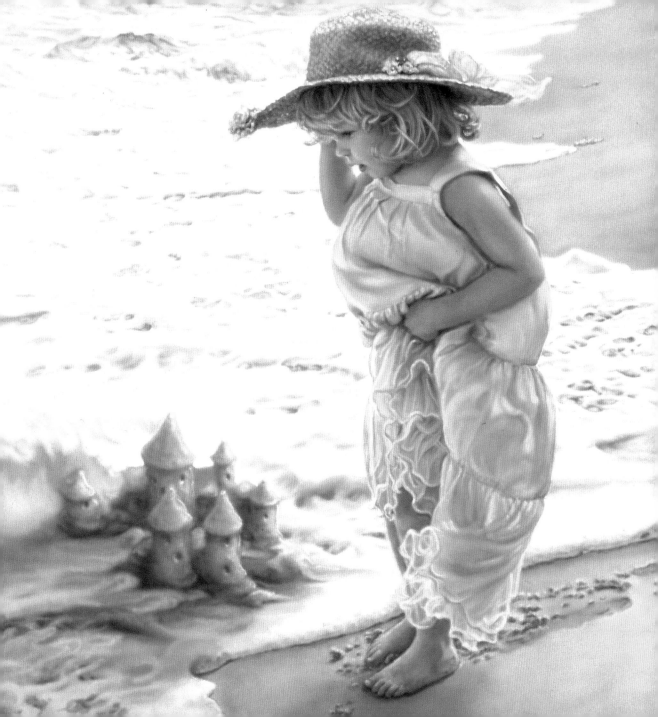

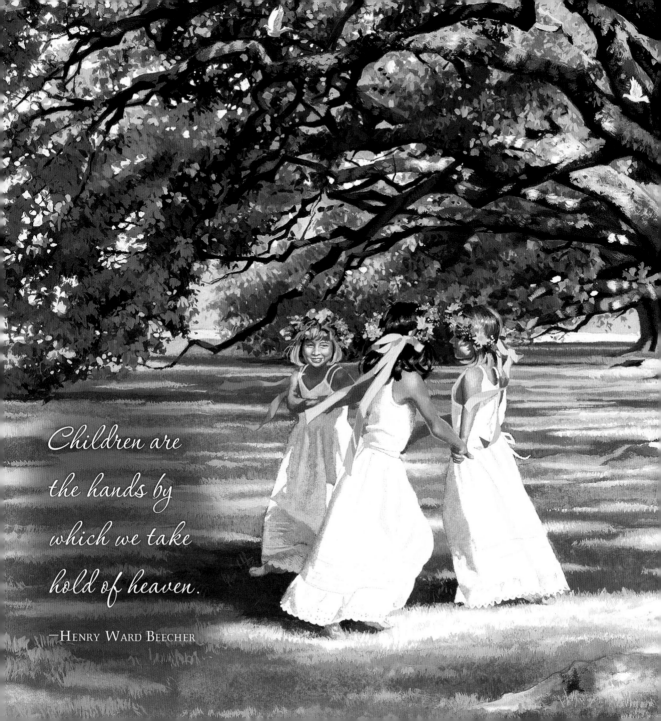

Children are the hands by which we take hold of heaven.

—Henry Ward Beecher

\mathcal{W}hen I approach a child,

he inspires in me two sentiments:

tenderness for what he is,

and respect for what he may become.

—*Louis Pasteur*

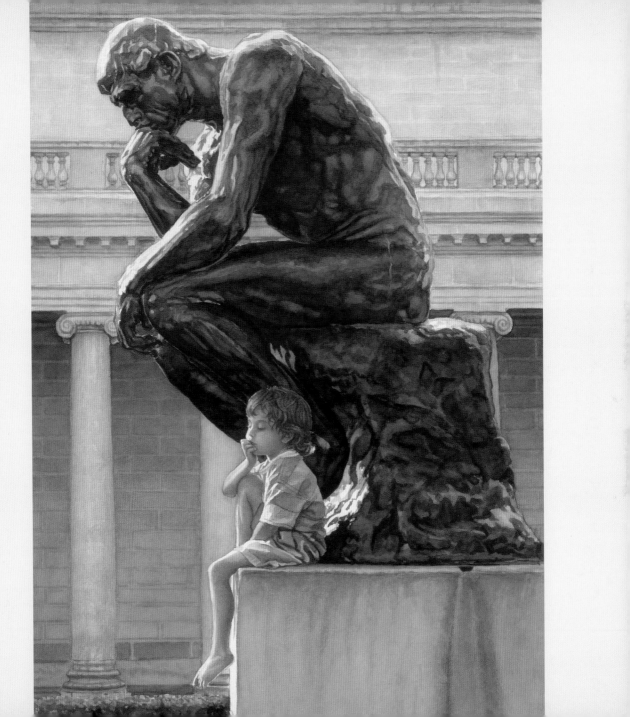